GALASHIELS
HISTORY TOUR

First published 2017

Amberley Publishing
The Hill, Stroud,
Gloucestershire, GL5 4EP
www.amberley-books.com

Copyright © Sheila Scott, 2017
Map contains Ordnance Survey data
© Crown copyright and database right
[2017]

The right of Sheila Scott to be
identified as the Author of this work
has been asserted in accordance with
the Copyrights, Designs and Patents
Act 1988.

ISBN 978 1 4456 6662 4 (print)
ISBN 978 1 4456 6663 1 (ebook)

British Library Cataloguing in
Publication Data.
A catalogue record for this book is
available from the British Library.

Origination by Amberley Publishing.
Printed in Great Britain.

INTRODUCTION

A flavour of past and present Galashiels – once famous for its textile mills and industry. This guide shows you around a town that has seen huge changes, particularly over the last decade. With the return of the Borders Railway to the town in 2015, it seems appropriate for your journey to start and finish with the train.

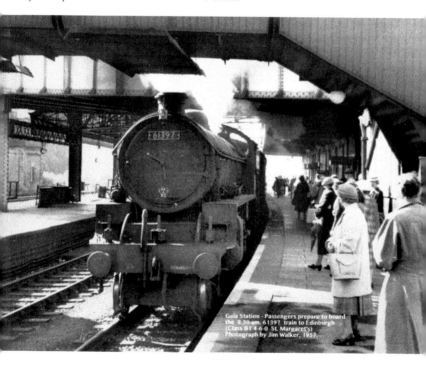

Gala Station - Passengers prepare to board the 8.50 am, 61397 train to Edinburgh (Class B1 4-6-0 St. Margaret's) Photograph by Jim Walker, 1957.

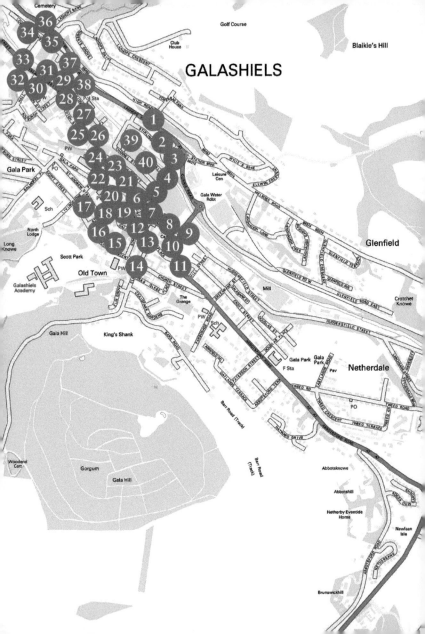

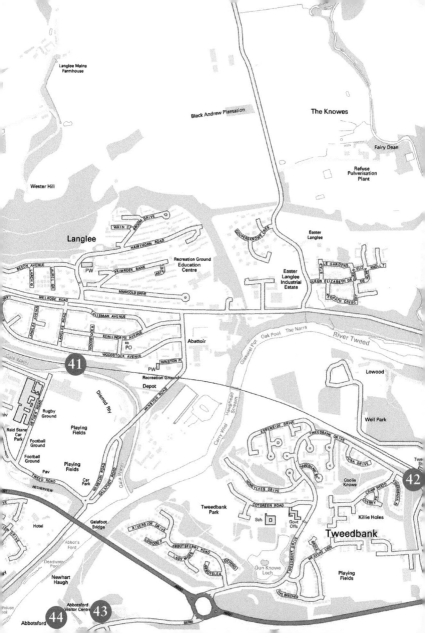

1. GALASHIELS STATION

In 1917 the cost of the fare to Edinburgh was put up from 1*d* to 1½*d* a mile (old currency) 'as the train had got faster'. The train seen in the photograph has, unusually, two engines, which suggests it was carrying a heavy load.

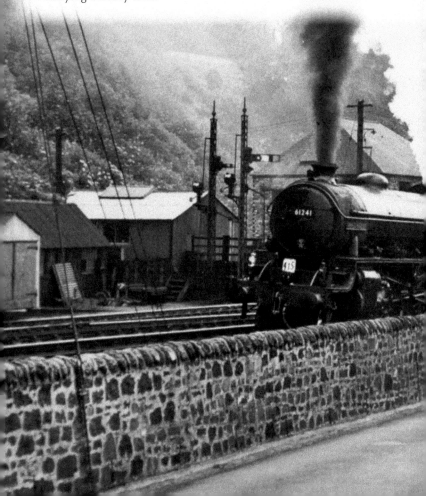

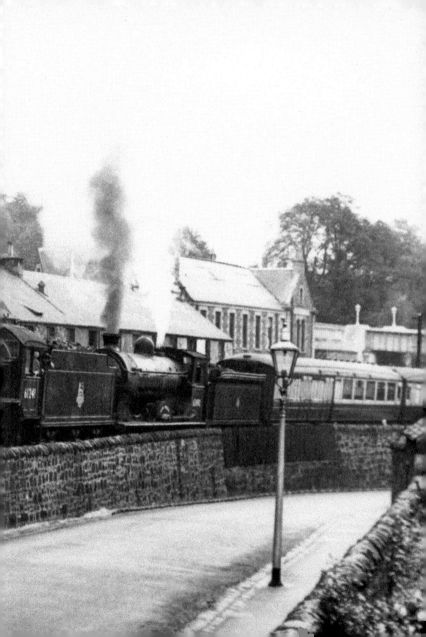

2. NEW TRANSPORT INTERCHANGE

Ladhope Vale in 2015, with two-way traffic and a railway line alongside. The new interchange building is used by both the railway and new bus station, accessed from Stirling Street and Ladhope Vale.

From the train, cross onto Stirling Street and turn left.

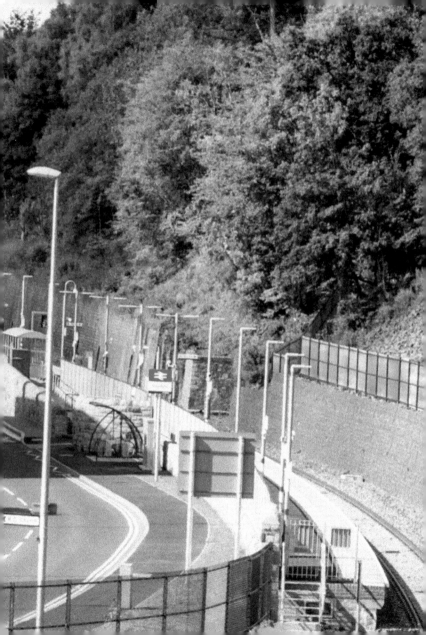

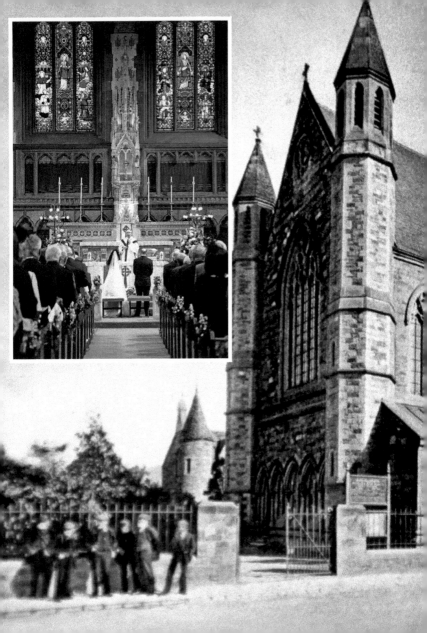

3. CHURCH OF OUR LADY & ST ANDREW

The Church of Our Lady & St Andrew was completed in 1858 and extended in 1870. This exterior remains almost unchanged today; however, the gentlemen in the old image would get quite a shock at the amount of fast-flowing traffic if they were suddenly transported back to that particular corner. The new road, which comes along the front gates of the church, carries traffic into the town centre and beyond. The interior of the church, with lovely stained-glass windows and an altar is a joy to use for a wedding photographer. The bride in the wedding shown is Celeste Mitchell, a descendant of the Macari family mentioned on page 52.

Proceed along here past the Catholic church and turn right into Market Street.

4. THE MARKET SQUARE

These images strangely look as busy as one another, despite being taken so many years apart! The new image sadly shows the town as it is in 2015, with too many empty shops.

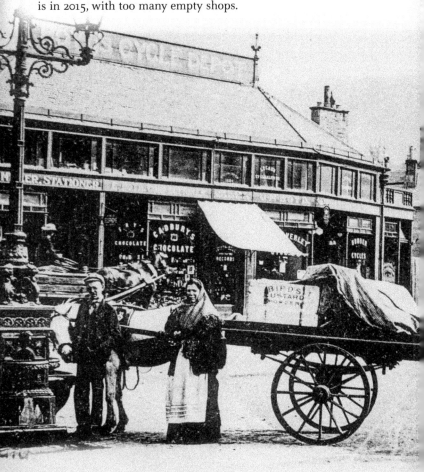

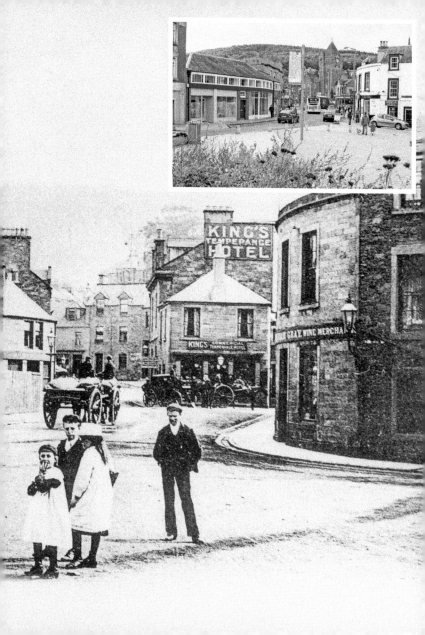

5. JAMES BEVERIDGE LTD

This old image shows the premises of what was James Beveridge Ltd, licensed grocers. The premises were taken over by Mitchell Glass in 1960, and having changed hands several times since, is now occupied by Quins Restaurant and Coffee Shop, named after Roger Quin, the poet who wrote 'The Borderland' – one of his best-loved poems.

From the moorland and the meadows
To this City of the Shadows
Where I wander old and lonely, comes the call I understand;
In clear, soft tones enthralling,
It is calling, calling, calling –
'Tis the spirit of the open from the dear old Borderland.

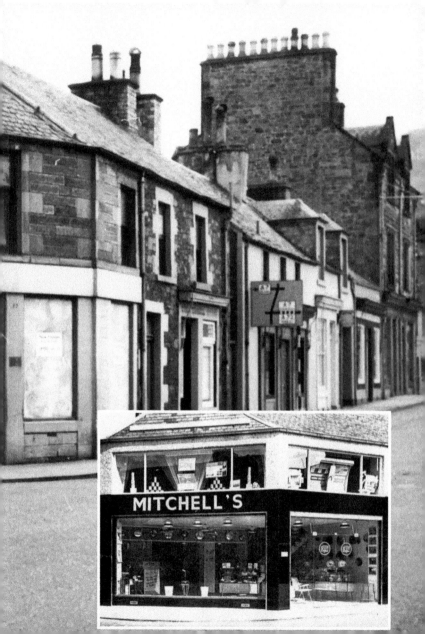

MITCHELL'S

6. THE OLD BUS STANCE

The old bus stance in Market Square at the bottom of Channel Street can be made out in this image taken in the late '50s. This image shows a Brooke & Co. vehicle and workers from Albert Place. The company is recorded in 1923, by then Brooke & Amos, as starting a service between Galashiels and St Boswells for a fare of 6d. They were taken over by SMT in 1926. Following this, SMT started the first direct bus service to Edinburgh from Galashiels in 1927.

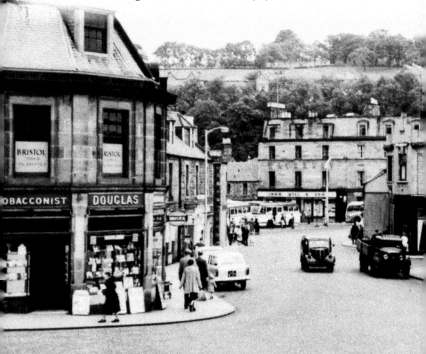

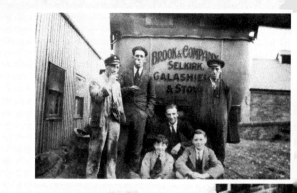

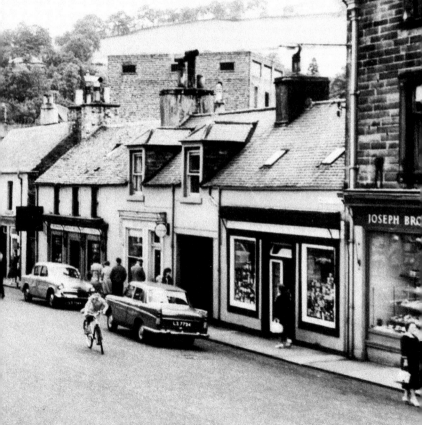

7. OLD CORN MILL

A pencil sketch by George Hope Tait shows an early view of the old Corn Mill. Some artistic licence would appear to have been used, but the library building and the small shops can easily be seen around the old mill. The latest image shows the appropriately named the Auld Mill pub, which is situated in Cornmill Square.

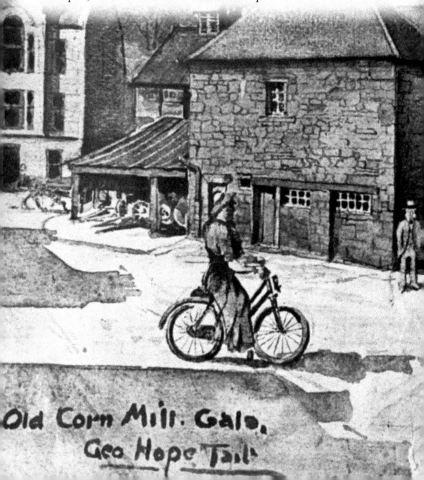

Old Corn Mill. Galo.
Geo Hope Tait

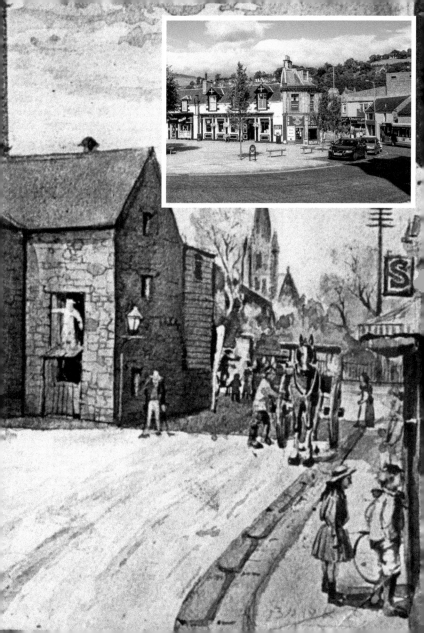

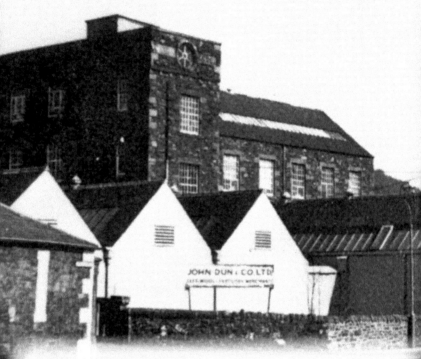

8. JOHN DUN & CO.

This image shows the premises of John Dun & Co., in Huddersfield Street, in around the 1960s, now demolished. The same area has High Street stores in its place. To the right on the roundabout – once the entrance to the Burgh Yard – a road gently climbs to join the Abbotsford Road in Albert Place, now known as Braw Lads Brae.

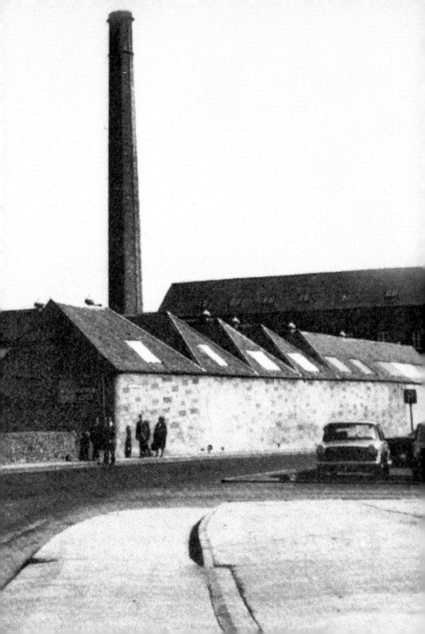

9. GEORGE CRAIG

Locharron of Scotland's mill building, Huddersfield Street, being demolished in 2006, having moved their head office and weaving production to Selkirk. The new road crosses the George Craig Bridge. George Craig (1783–1843) was a lawyer and agent of the Edinburgh & Leith Banking Co., the first bank to be established in the town. Situated in Elm Row, it failed in 1842. While out hunting with Sir Walter Scott one day, Mr Craig was accidentally hurt. This was part of Sir Walter Scott's account of the incident: 'Queen Mab lifted up her heels against Mr Craig, whose leg she greeted with a thump like a pistol shot. Mr Craig would not permit his boot to be drawn off, protesting he would faint. Some thought he was reluctant to exhibit his legs in their primitive and unclothed simplicity, in respect they have an unhappy resemblance to a pair of tongs.'

Go along Paton Street then turn right up Braw Lads Brae.

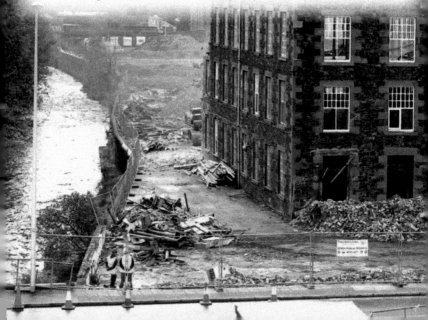

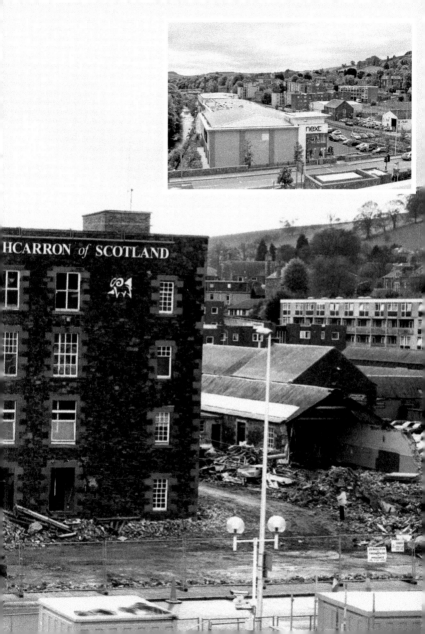

10. BRAW LADS BRAE

The old burgh yard was cleared in 2006 when the old garage premises, previously occupied by Chalmers McQueen, were demolished to make way for the new 'Braw Lads Brae'.

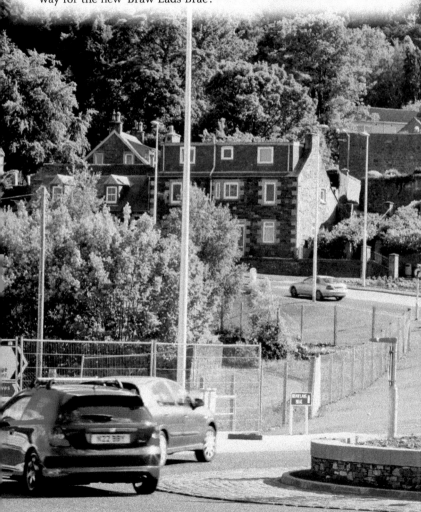

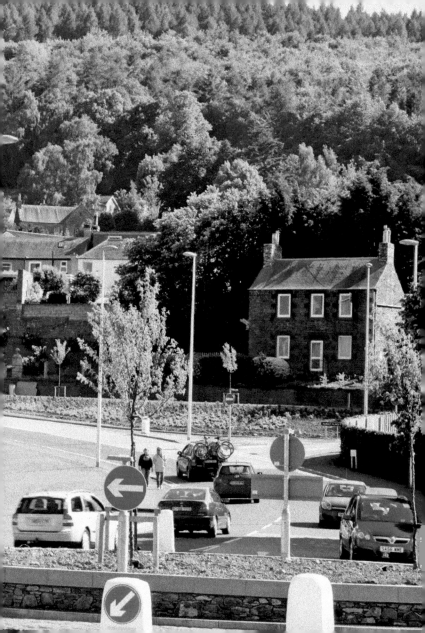

11. THE BOW BUTTS STEPS

The Bow Butt steps got their name from the first quarter of the seventeenth century when villagers over twelve and under sixty 'found opportunity for practice with bow and arrow on Sabbath afternoons at the conclusion of church service'. The Bow Butts was also the site of Logan's Stables in the late 1800's, where corporation carts and pigs were kept.

Proceed along Albert Place to the war memorial.

12. WAR MEMORIAL AND THE FOUNTAIN

Although the layout of the buildings remains similar, a huge amount of work has been done to give Galashiels a lovely pedestrian area around the fountain, opposite the war memorial.

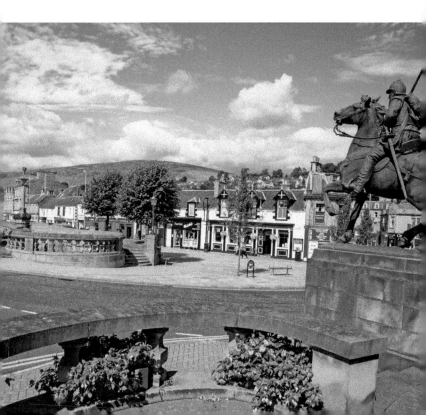

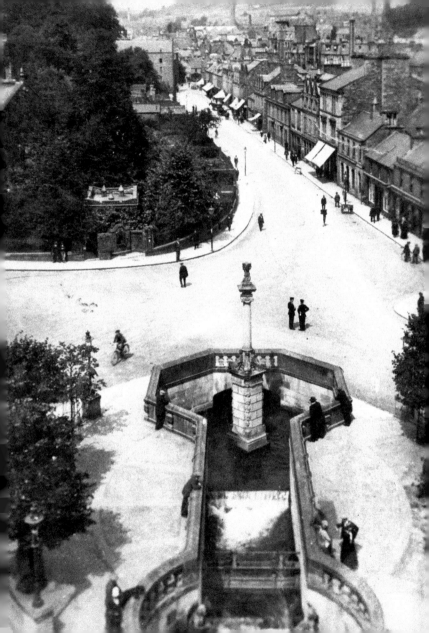

13. THE WAR MEMORIAL

A close-up taken at night of *The Reiver* at the war memorial. The inset shows the statue made to commemorate Robert Burns, erected in 1913.

Make a U-turn up Lawyer's Brae to . . .

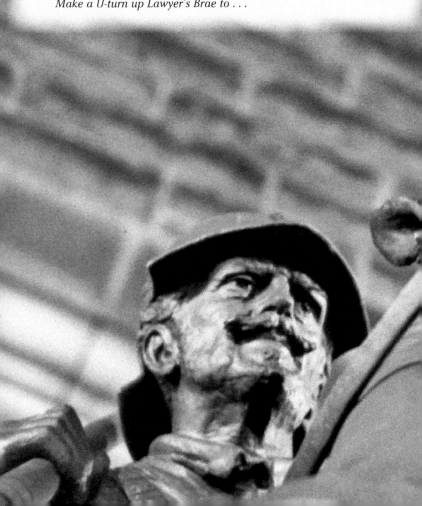

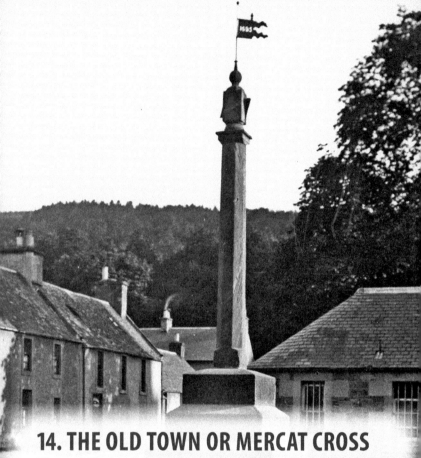

14. THE OLD TOWN OR MERCAT CROSS

The modren photograph showing the Old Town Cross decorated for Braw Lads' Day in 2000. A cross has occupied this old part of the town since 1599. Straight across from it, you can see the entrance to Tea Street. The houses on one side of this street were built in the late seventeenth century.

Proceed along Scott Crescent, past Old Gala House, then turn right into St John Street and follow down to Bank Street (past the bust of Sir Walter Scott on your left).

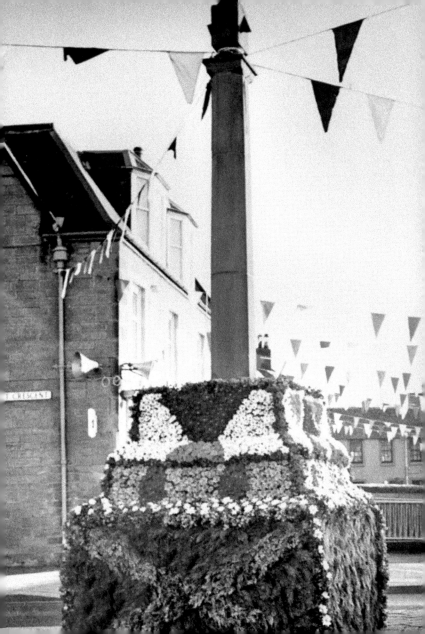

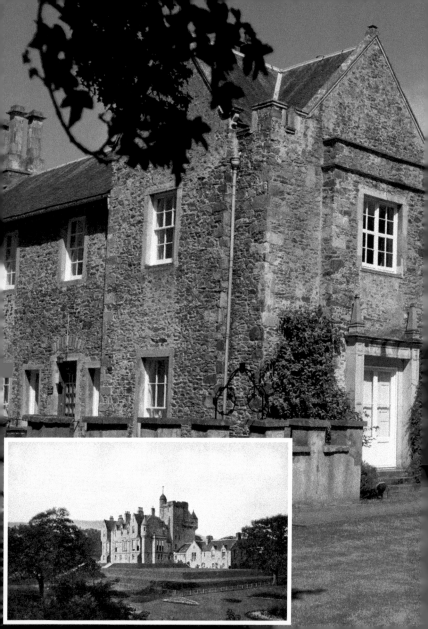

15. GALA HOUSE

Built in 1877, it was situated in Gala Policies. After it was vandalised, it was then sold in 1978 for £7,000. Old Gala House, now standing in Scott Crescent, is a popular gallery, museum and meeting place with lovely gardens and facilities.

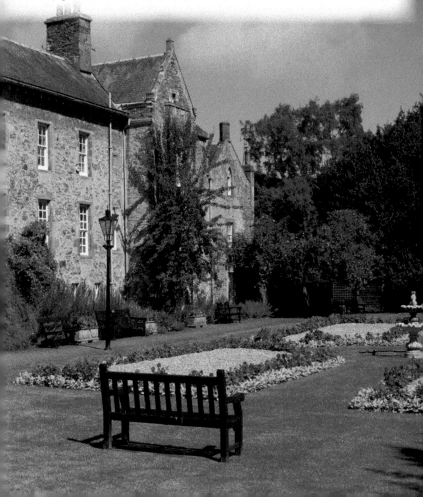

16. SCOTT CRESCENT

In the late 1800s the town had two dairies in Church Street; one belonging to Johnny Cunningham and the other Jock Anderson's. Cows are seen here coming down Scott Crescent, which if it were to be done these days would require a lot of thought and advanced planning.

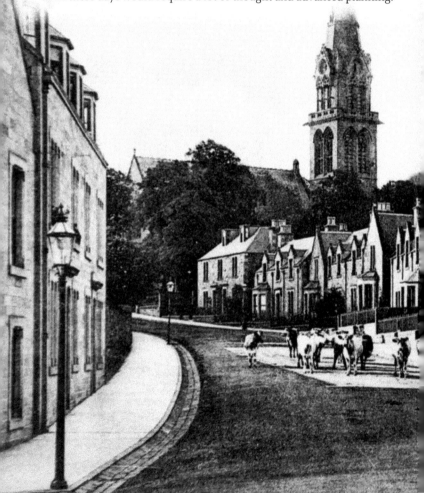

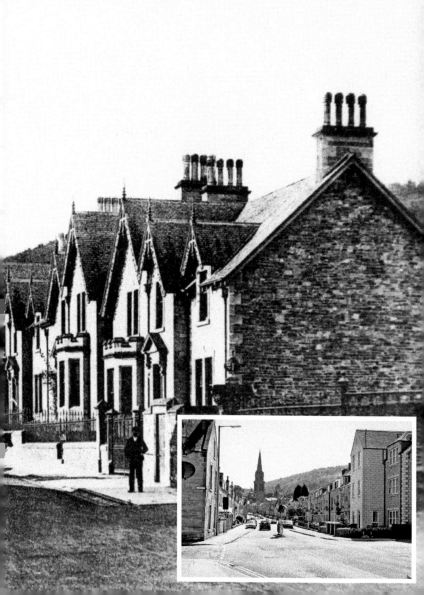

17. BRAW LADS' DAY

Burgh Police Sergeant Waugh was the last mounted police officer Galashiels had. He is seen here riding on the first Braw Lads' Day, in Scott Street in 1930. The police mounted section is now centralised in Ayrshire to cover the whole of Scotland.

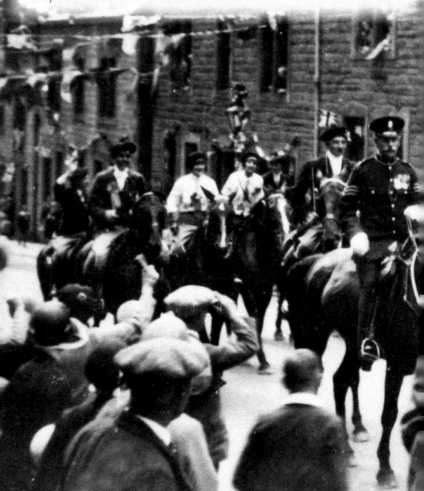

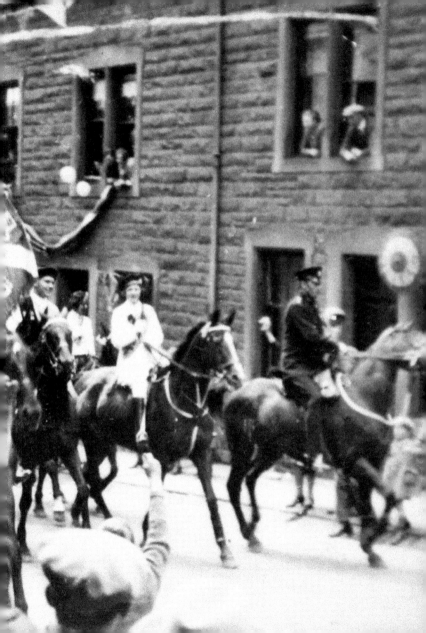

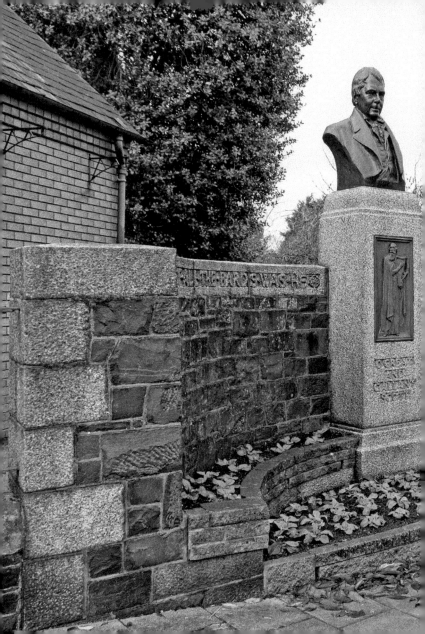

18. THE BUST OF SIR WALTER SCOTT

This is a monument to the famous historical novelist, playwright and poet Sir Walter Scott (1771–1832), whose family home 'Abbotsford' can be visited at the end of this tour. The bust and tablet were made by Thomas Clapperton (1879–1962), a Scottish sculptor born in Galashiels who was commissioned to mark the centenary of Scott's death in 1932.

19. LIPTON'S TEASHOP

Bank Street showing what was the Lipton's Teashop and Grocers around 1930, now the House of Hearing. The old image shows Mr Peters, centre, along with Dick Prosser, George Ramsay, Ella Liddle and Arthur Hancock.

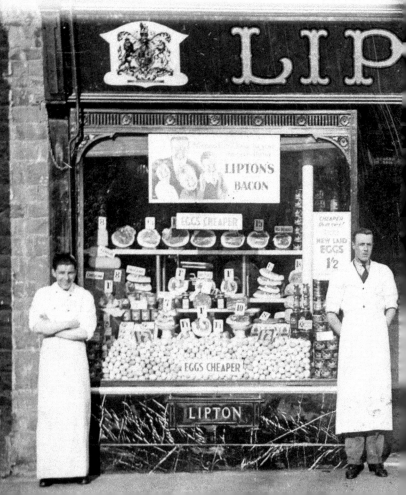

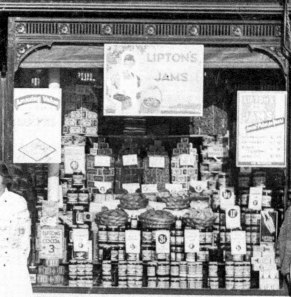

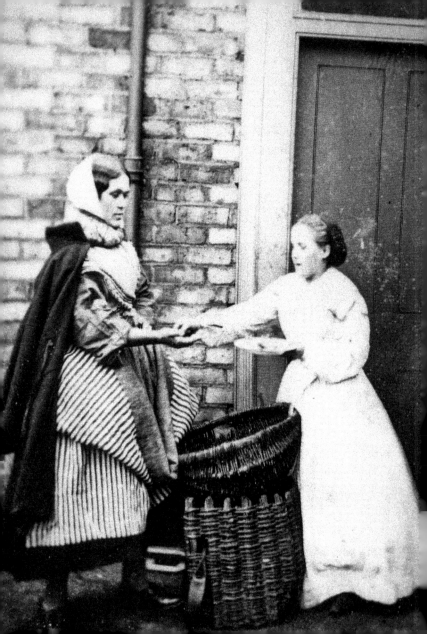

20. FISHMONGERS

The arrival of the railway to Galashiels in 1849 brought many benefits, not least the easy transportation of coal to power the tweed mills' looms, replacing water power. It also allowed fishwives from Newhaven to sell fresh fish in The Borders. This traditionally garbed fishwife with her creel and basket was photographed by Kirkwood of No. 21 Bridge Street around 1860. The image below shows Dave Crichton with Julia Noble in Noble's Fishmongers in Bank Street. Fishmongers have been in these premises for approximately 100 years.

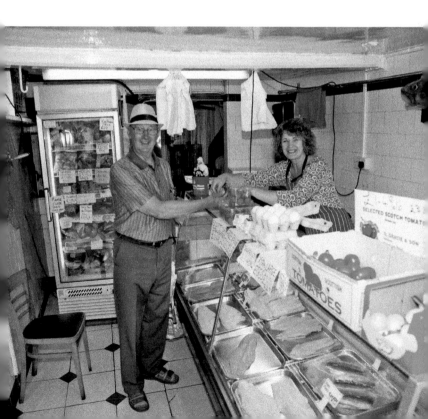

21. FRASER & ALLIN

Fraser & Allin can be found in the middle of Bank Street, having previously been in Channel Street and Island Street. Jim Fraser and John Allin met in the trenches during the First World War and said that, if they survived, they would start a business. The owner today, Jim Lees (right), runs the businesses. He joined his father as an apprentice in 1960, taking over from him in 1972.

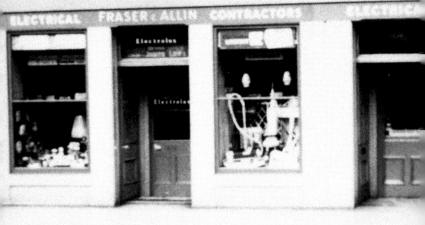

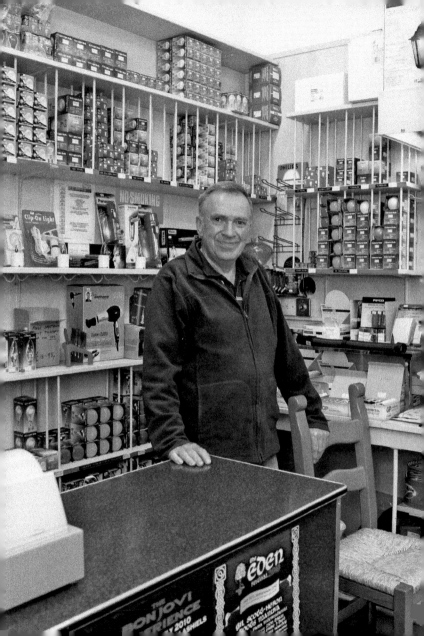

22. BANK STREET GARDENS

On the opposite side of Bank Street, the gardens are constantly maintained to a high standard by the park's department, and throughout the year, they provide a lovely floral display for visitors and locals alike.

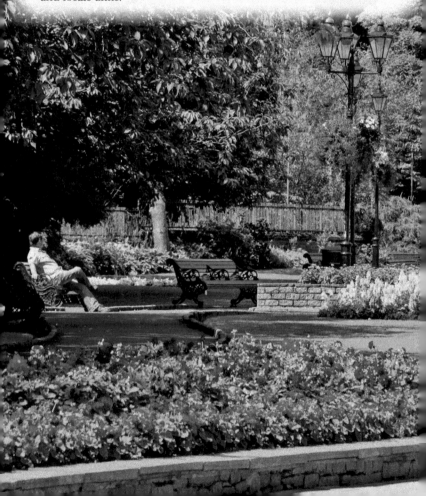

23. BANK STREET

The views from the top end of Bank Street looking down show a similar layout despite there being a 100-year difference, and missing a war memorial. Like Channel Street, although appearing busy, it sadly shows the state of the economy with the many 'Shop For Sale' signs.

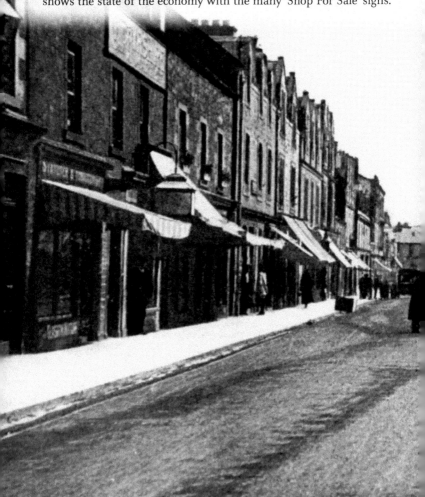

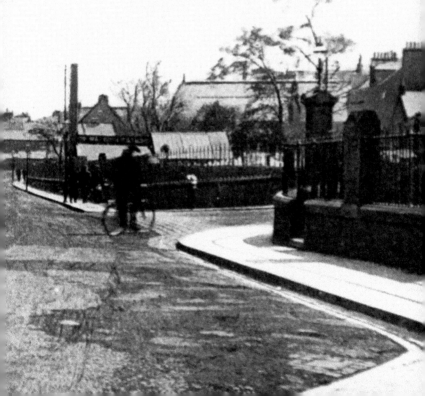

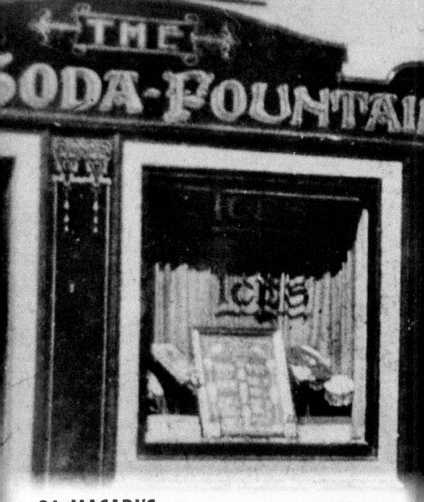

24. MACARI'S

Giovanni was the first of the Macari family to come to Galashiels, opening The Gala Soda-Fountain in 1924. He was followed by his son Tony and in turn, his son Phillip, who now runs the Macari family business in the town, seen here (*see* inset) in the same premises today.

25. GEORGE HOPE TAIT

Born in 1861, George Hope Tait came to live in Galashiels before the time of the first Gala Day. This is a painting he did of the family house and business that he and his brother built at No. 26 High Street (left). The plaques on the Old Town Cross (*see* 14.) were designed by George Hope Tait and would lead us to imagine he may have had some influence in the first Braw Lads' Day. Records would seem to suggest that he was instrumental in doing research that had some bearing on the formation of the ceremonies we now see on Braw Lads' Day.

26. TRINITY CHURCH

Built and named 'United Secession Church' in 1844, this church has had several unions and name changes over the years – St. Ninians, St. Columba's and East United Presbyterian. Following a union with St Aidan's Church, it was renamed 'Trinity' in 2006. The name 'Trinity' came from a church that was at one time located slightly further up the High Street (now a Wetherspoon's pub called Hunter's Hall).

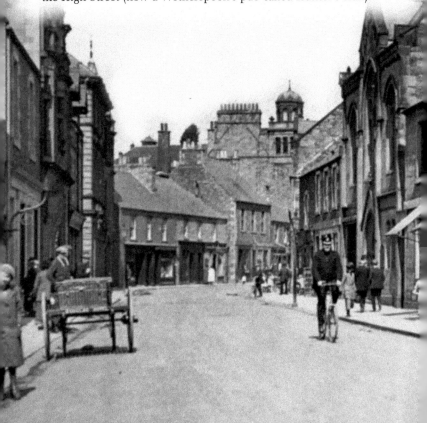

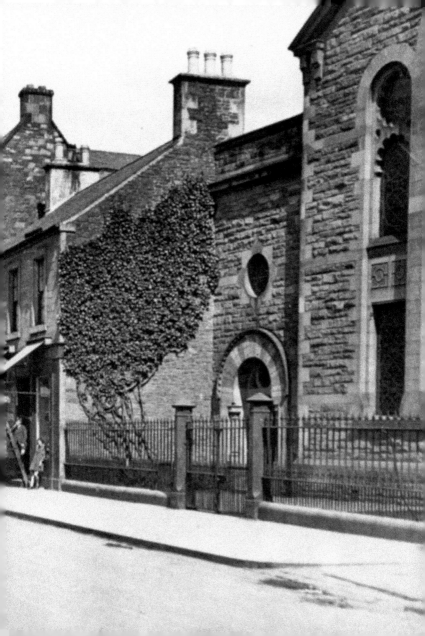

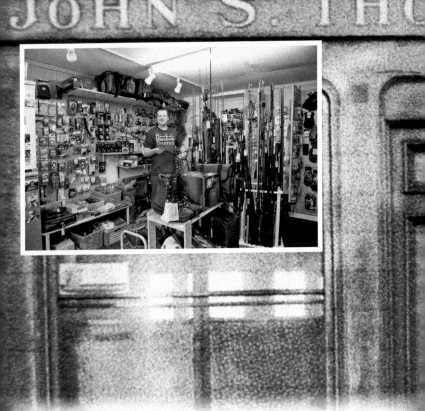

27. JOHN S. THOMSON, SADDLER

Further up the High Street, the old photograph shows John Thomson who operated a saddler's business at No. 97 around the 1930s. There are no saddlers working in the town now and, having taken many forms over the years, this shop is now run by Mike Allan of the Border Angling Centre. Back in 1946, the almanac and directory published by John McQueen & Son recorded two saddlers and four fishing tackle makers in Galashiels.

Carry straight on at the crossroads into . . .

28. ISLAND STREET JUNCTION

The junction of Island Street and High Street is a part of the town centre that still has a similar layout as it did in the 1890s. The old Royal Bank can be seen on the left-hand side, now a pub/restaurant.

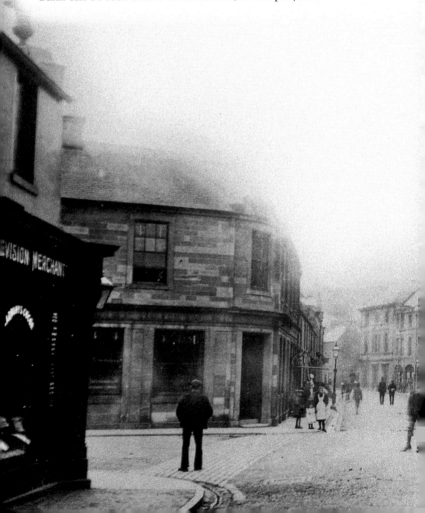

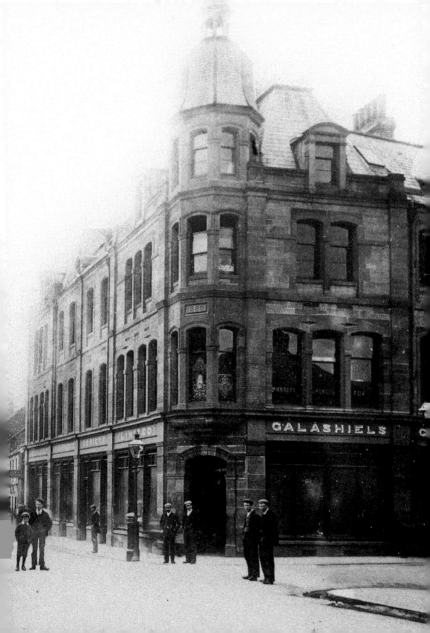

29. ISLAND STREET

Alex Dalgetty & Sons can be seen this old image, where the baker's horse and cart stand on the left. The original bakery was in Gala Park and moved to Island Street in the early 1900s. This is still a family business. Craig Murray, great-great-grandson of Alexander Dalgetty, works in the bakery. The ovens, still in use, are over 100 years old.

30. THE SELKIRK BANNOCK

Next door we see what used to be Michael Moore's constituency office. He became the first backbencher in living memory to go straight to cabinet minister in 2010 when he was appointed Secretary of State for Scotland. One of his first duties was to host a reception at Dover House in London for 100 dignitaries, for which he ordered six large Selkirk Bannocks from Dalgetty's to serve to the guests. The inset shows Craig Murray making Selkirk Bannocks at 4.30 a.m. using his great-great-grandfather's recipe.

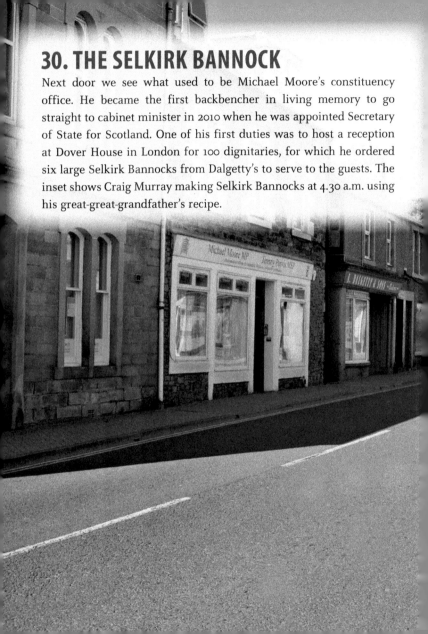

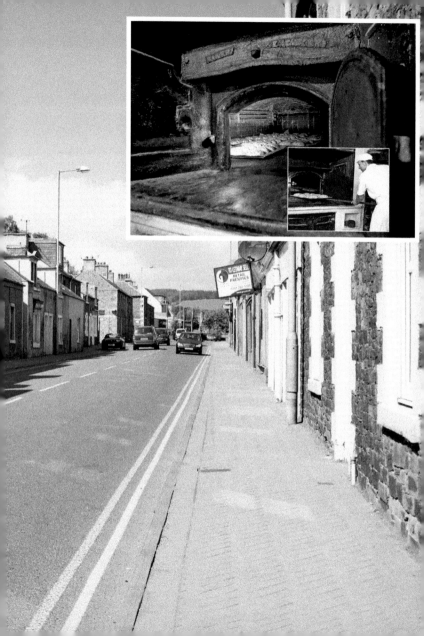

31. SANDERSON & MURRAY

Sanderson & Murray was founded in 1844 as a fellmongers and wool merchant in Wilderhaugh, Galashiels. The business suffered three fires during its time – 1873, 1882 and 1923 – rising from the ashes on each occasion. The old image here shows the clock tower, which was never rebuilt after one fire. There is no longer any sign of the skin works, which, at its peak, would employ around 300 people. All that is left are the offices, now occupied by Cameron Architects.

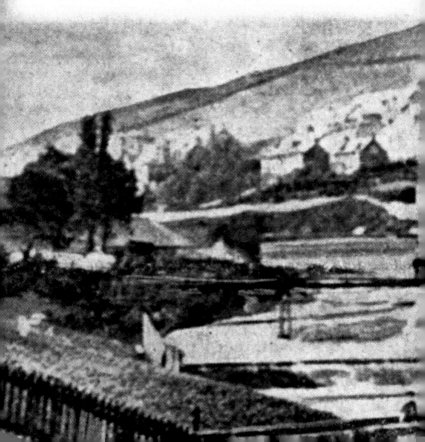

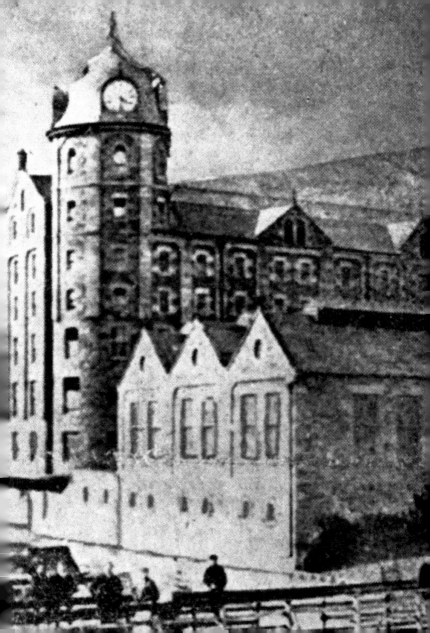

32. WORKERS

A group of ladies from a local darning department pose for a group photograph in the early 1920s. One tradition among the millworkers in years gone by was to get a coat or jacket belonging to a bride-to-be, decorate it with small household items and hang it outside the mill where she worked. Later, she would wear it home.

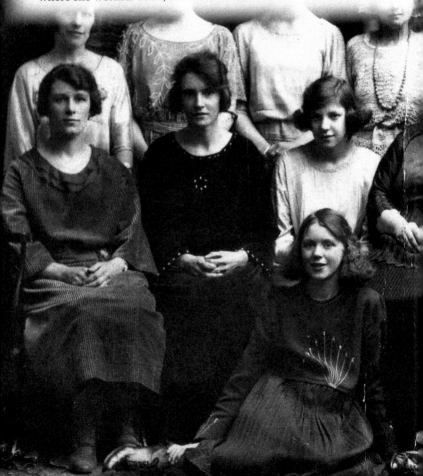

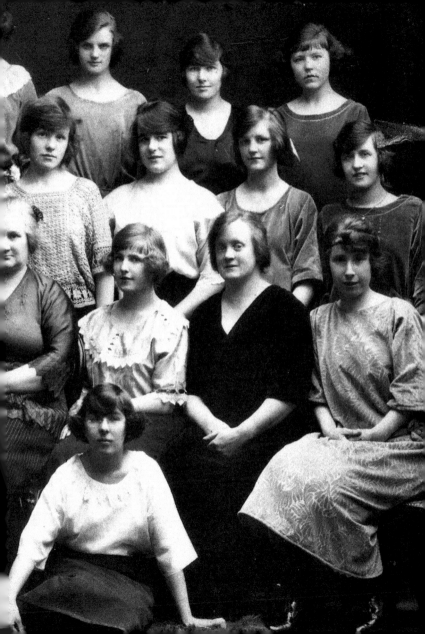

33. THE MILL LAID

Situated in the Wilderhaugh area, the Mill Laid is difficult to view as it was. The inset image shows Sinclair Chalmers, James Davy, John Morrison, Jackie Kennedy, and Arthur and Ronnie Ballantyne in the late '20s having fun in the water.

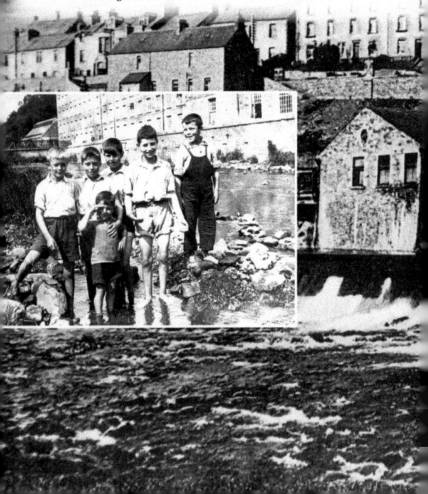

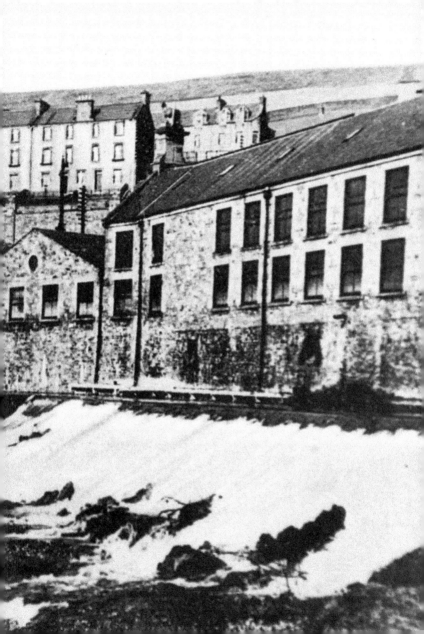

34. NEW RAILWAY BRIDGE

The railway bridge is situated roughly where the old brewery (*see* pages 74–75) used to stand. It now connects Low Buckholmside with High Buckholmside. The inset shows how High Buckholmside used to look.

Up Low Buckholmside onto High Buckholmside.

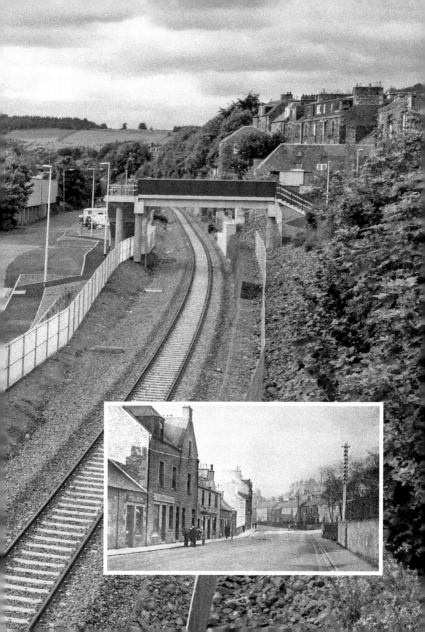

35. GALASHIELS BREWERY

Galashiels Brewery commenced in 1804 – started by a group of five men including the Revd Dr Douglas in Low Buckholmside for the 'production of London porter'. A copy of a letter from one James Dalrymple of Edinburgh in 1807 to Gallowshiels Brewery complained 'that the ale was never of any use and it soured on his hand!' This particular brewery closed in 1809, which suggests he may have been right!

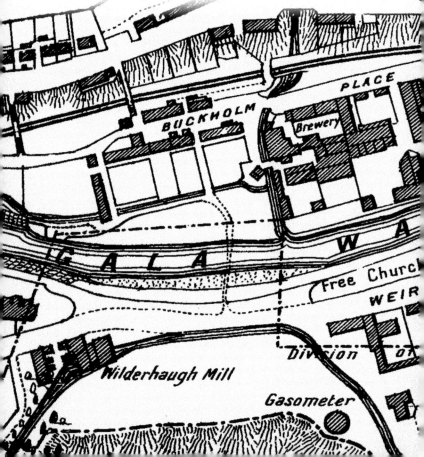

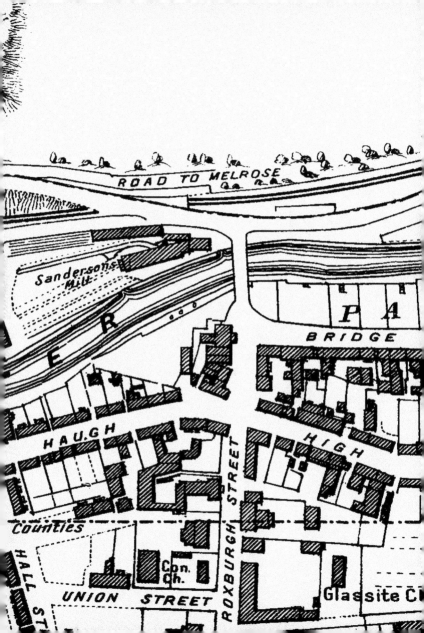

ROAD TO MELROSE

Sandersons Mill

E R

E

P A

BRIDGE

HAUGH

HIGH

ROXBURGH STREET

Counties

HALL ST.

Con.
Ch.

UNION STREET

Glassite C

36. THE LADHOPE INN

This image shows the Ladhope Inn today, which sits above the area where the brewery once was. It bears a plaque outside reading 'Established 1792', proving it a much more successful venture than the brewery!

37. FIRE AT THE MILL

This image of a mill fire in 1928 shows the site of where Laidlaw & Fairgrieves Mill was recently demolished to make way for a new housing complex. This is now best viewed from the opposite direction, from the High Road, the spot where hundreds of onlookers can just be seen on the right of the picture, lining the wall to view the fire in the mill.

Take a right here down into Bridge Place.

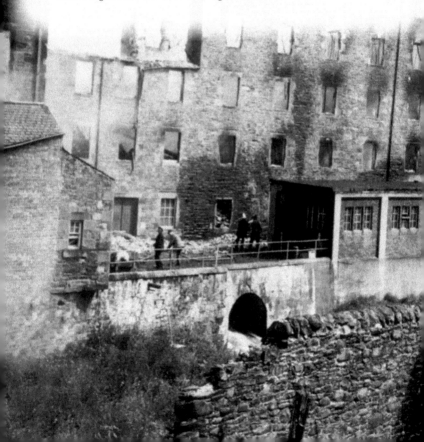

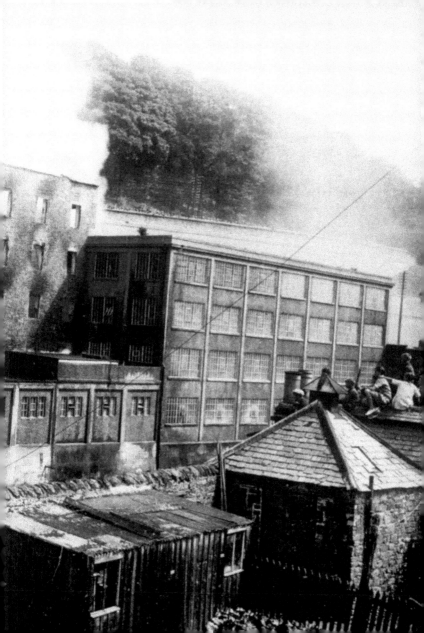

38. LADHOPE TUNNEL

In December 1916, the retaining walls at Ladhope Tunnel collapsed and had to be rebuilt. Workmen are seen in the inset image posing for the photographer on the steep embankment. Today, the walls of the tunnel have been strengthened to take the reinstated railway line.

Turn left into Bridge Street.

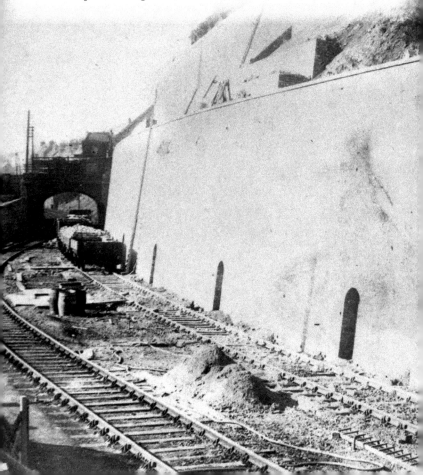

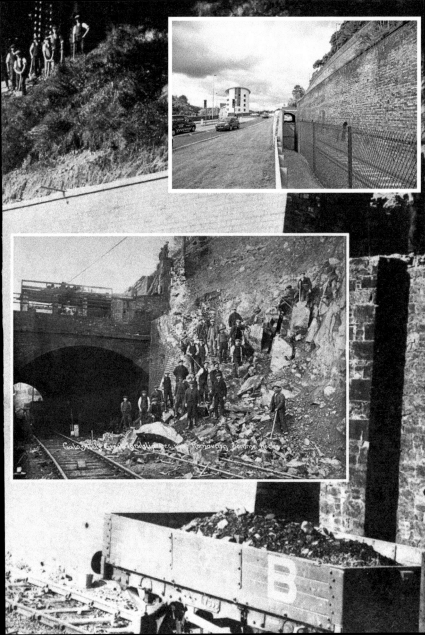

Galashiels Goods (Engine Men(?) Removing Some(?) Rocks

39. THE PAVILION

'The Piv' (The Pavilion) in Channel Street, home to cinema and other productions, was demolished in 1970. The inset image was taken after the new proscenium was added along with the extension of seating etc. to the right-hand side (1930s). The interior of The Playhouse, which was situated further down at the bottom end of Channel Street, opened in 1920. This building is a cinema and bingo complex but now uses the name 'The Pavilion'.

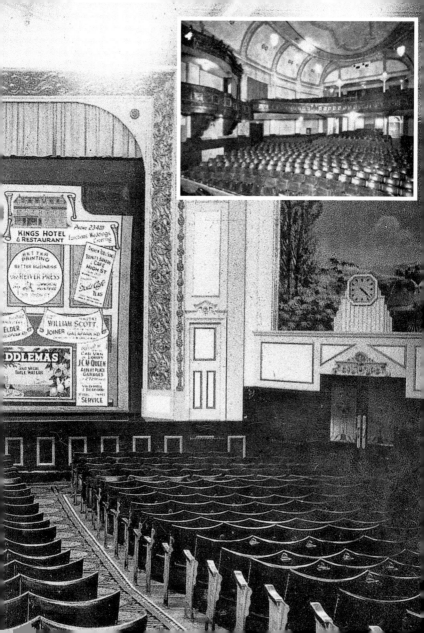

40. CHANNEL STREET

The photograph on this page shows how Channel Street used to look. It is now occupied by shops, although many independent shops find rates prohibitive in the town centre.

Turn left and proceed along Douglas Bridge back to the Transport Interchange.

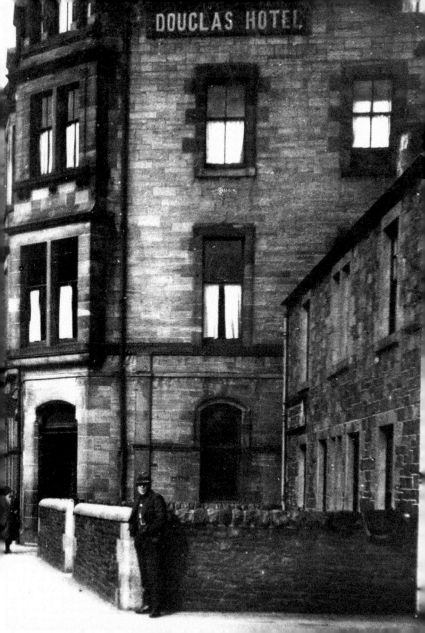

At this point, take Train for a very short journey to Tweedbank (see map 2), passing the Heriot Watt and Borders College Campus on the right, and the grounds of Gala RFC and Fairydean FC.

41. BORDERS COLLEGE AND FAIRYDEAN FOOTBALL PITCH

The aerial shot shows the present college and university facilities available in the town, sited in Netherdale, close to the Gala Rugby and Fairydean Football pitches. In 2009, Borders College moved from Melrose Road to within the Heriot Watt University campus at Netherdale. This is an excellent facility and the inset shows a recent image of Borders College staff at the campus building.

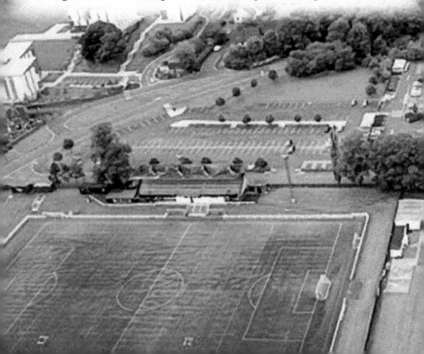

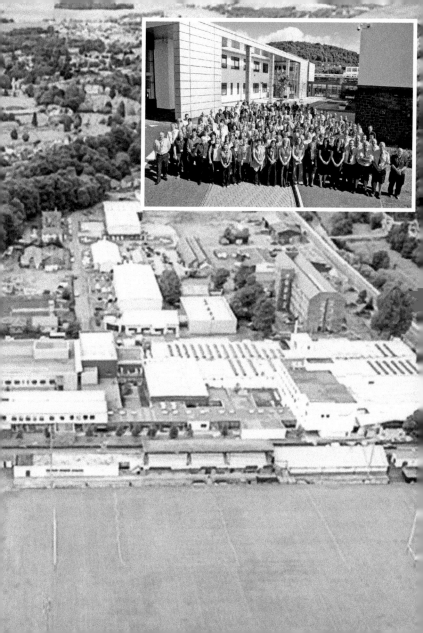

42. TWEEDBANK RAILWAY STATION

Tweedbank, an outer suburb of Galashiels, now has a railway station (completed in September 2015). This is where the new Borders Railway (Waverley Line) ends. It provides visitors with walking access to Abbotsford House – home of Sir Walter Scott and a very popular tourist attraction.

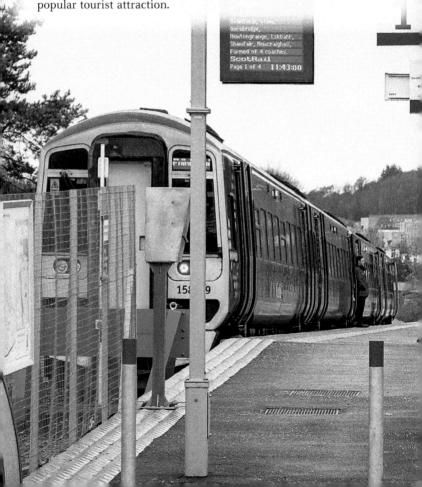

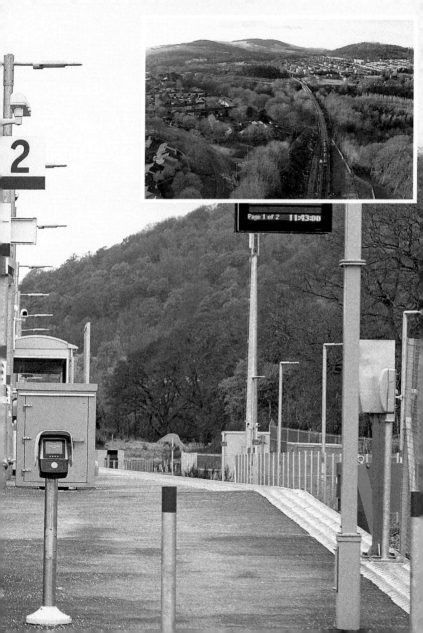

43. ABBOTSFORD HOUSE

The home of Sir Walter Scott, born 1771. In 1812 he had moved there from Ashiesteel, having purchased the property known as Cartley Hole on which he built Abbotsford. He was the first to wear a pair of trousers made of Scottish shepherd check plaid. It is a custom for these checks to be made for, and worn by, all Braw Lads on the Gala Day. Abbotsford received a multimillion-pound renovation and restoration during 2011–2013. Closed to the public during this time, it was officially opened by Her Majesty the Queen in 2013.

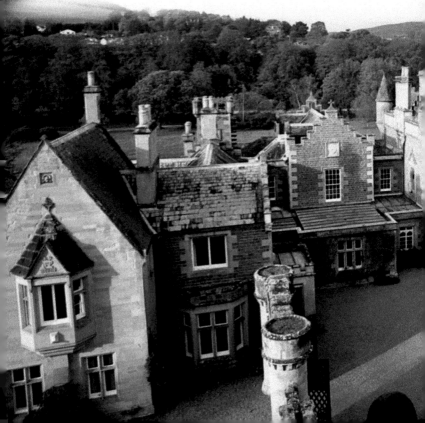

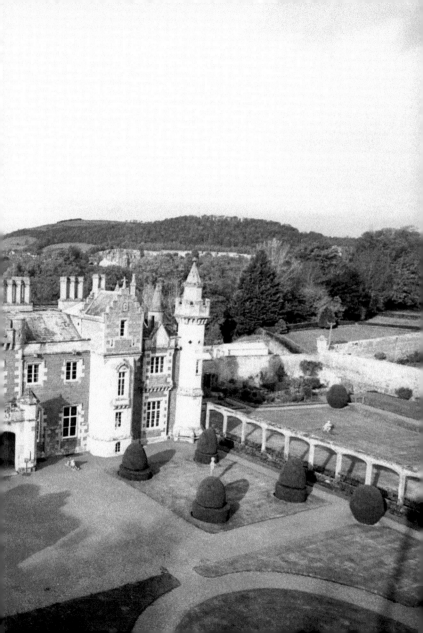

44. SIR WALTERS SCOTT'S COLLECTION

The contents of Scott's library and study had to be removed prior to renovation work taking place in Abbotsford. The historic collection was carefully moved to the Faculty of Advocates in Edinburgh. The two photographs show the library prior to and after the renovation.

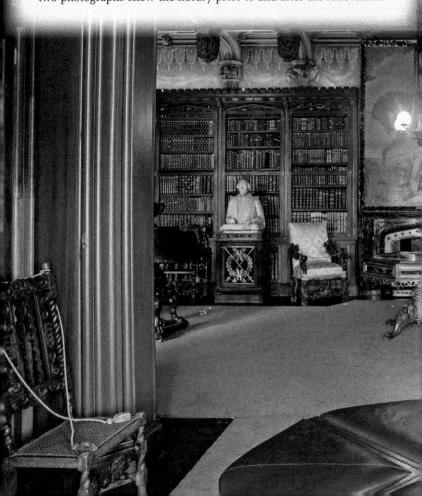

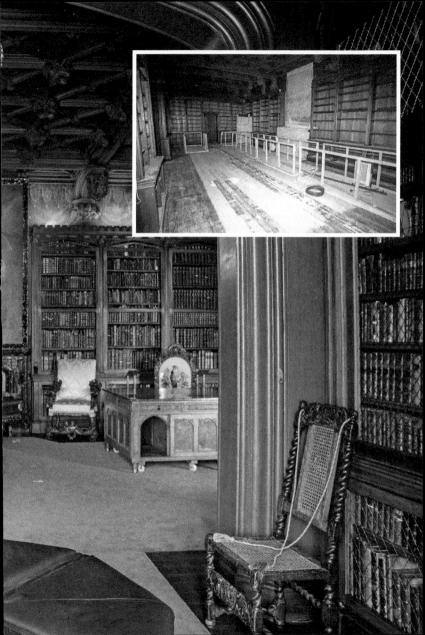

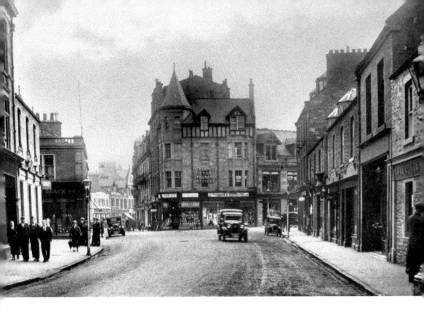

ABOUT THE AUTHOR

Sheila Scott has been a professional photographer in Galashiels for around thirty years. With an interest in pictorial history, she has produced several books that illustrate the past and present.

ACKNOWLEDGEMENTS

My grateful thanks to James T. Walker, F. R. P. S., Justin Mihulka, Ron Ballantyne, Philip Macari, Phyllis Hancock, Craig Murray, Mary Young, Pat McMorran, Sandra Aitchison, Jim Lees, John Gray, Borders College and RC Innovations, and all who assisted me with this book.

Also Available from Amberley Publishing

SHEILA SCOTT

GALASHIELS

THROUGH TIME

This fascinating selection of photographs traces some of the many ways in which Galashiels has changed over the last century.

Paperback
180 illustrations
96 pages
978-1-4456-0040-3